CHILL OUT WITH
Mandala
COLORING

by @ALEXISGENTRY

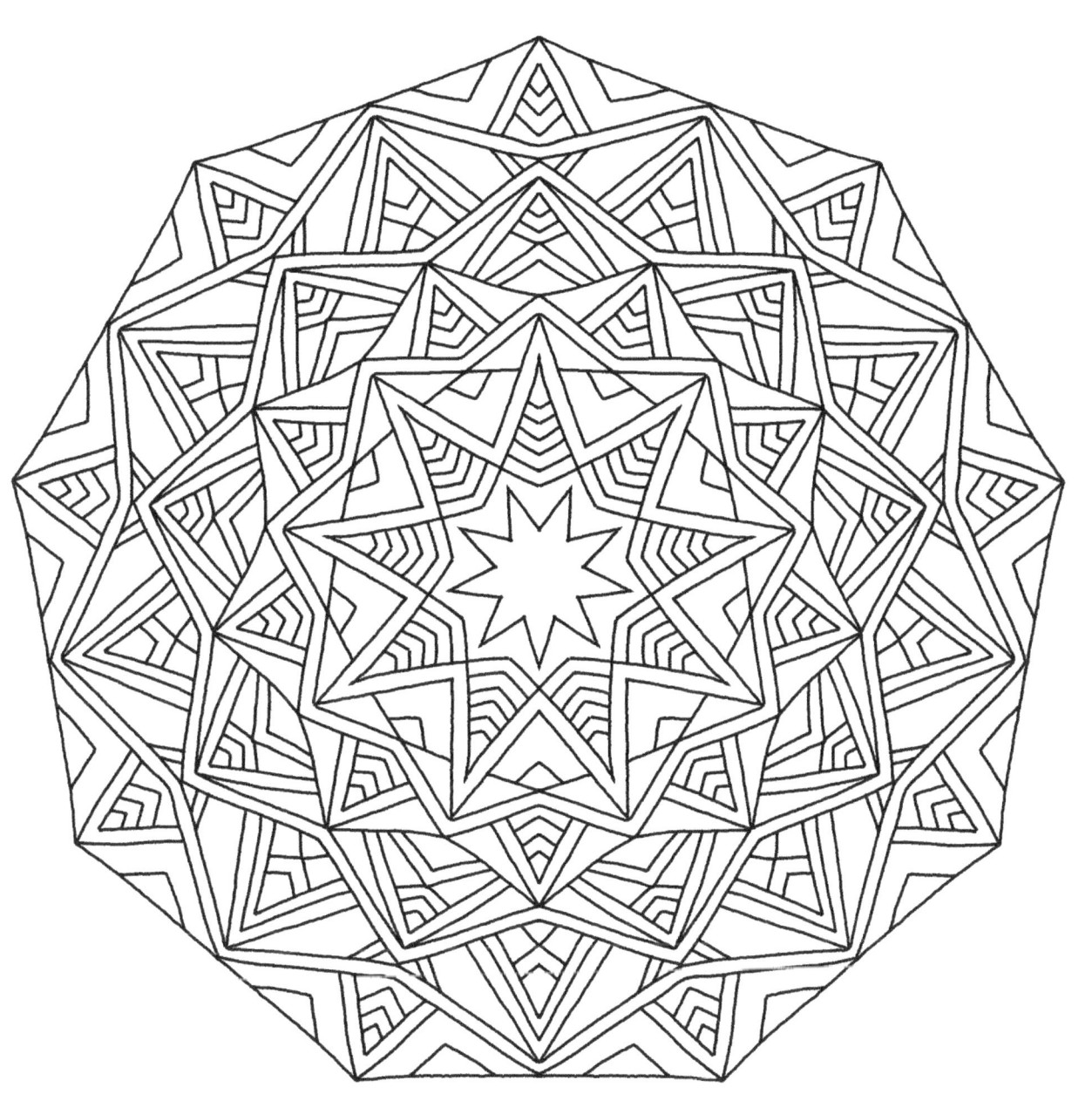

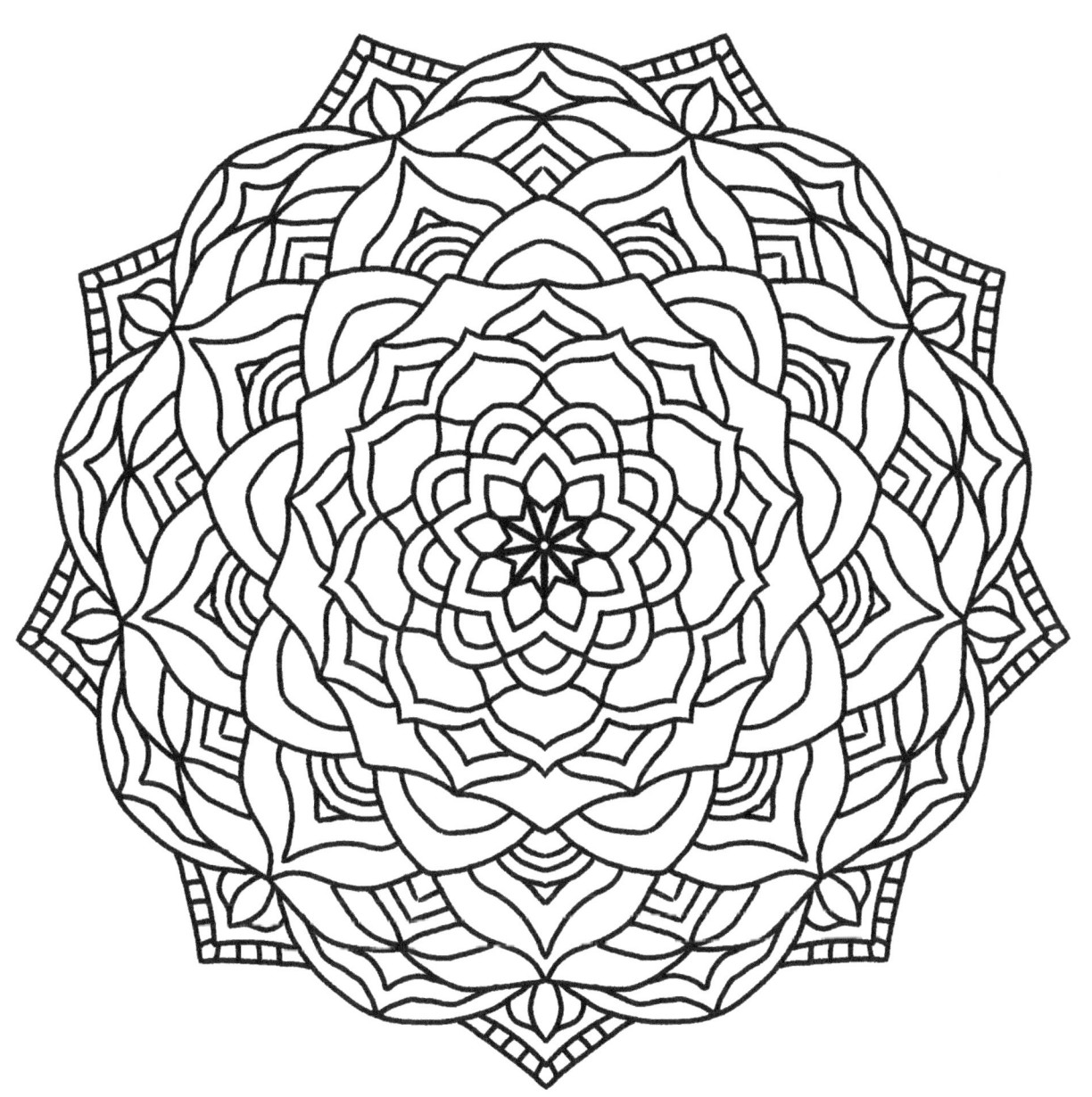

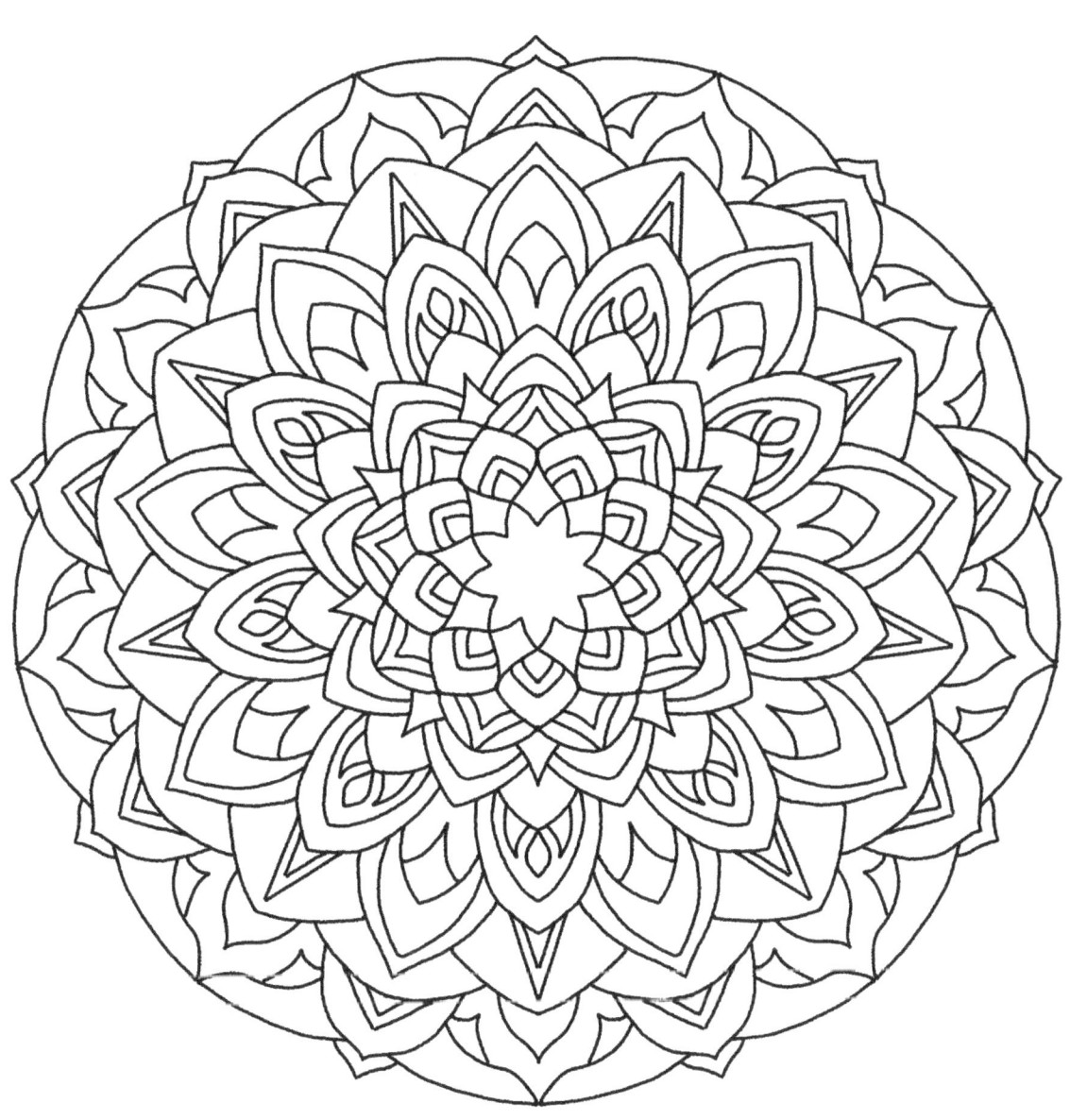

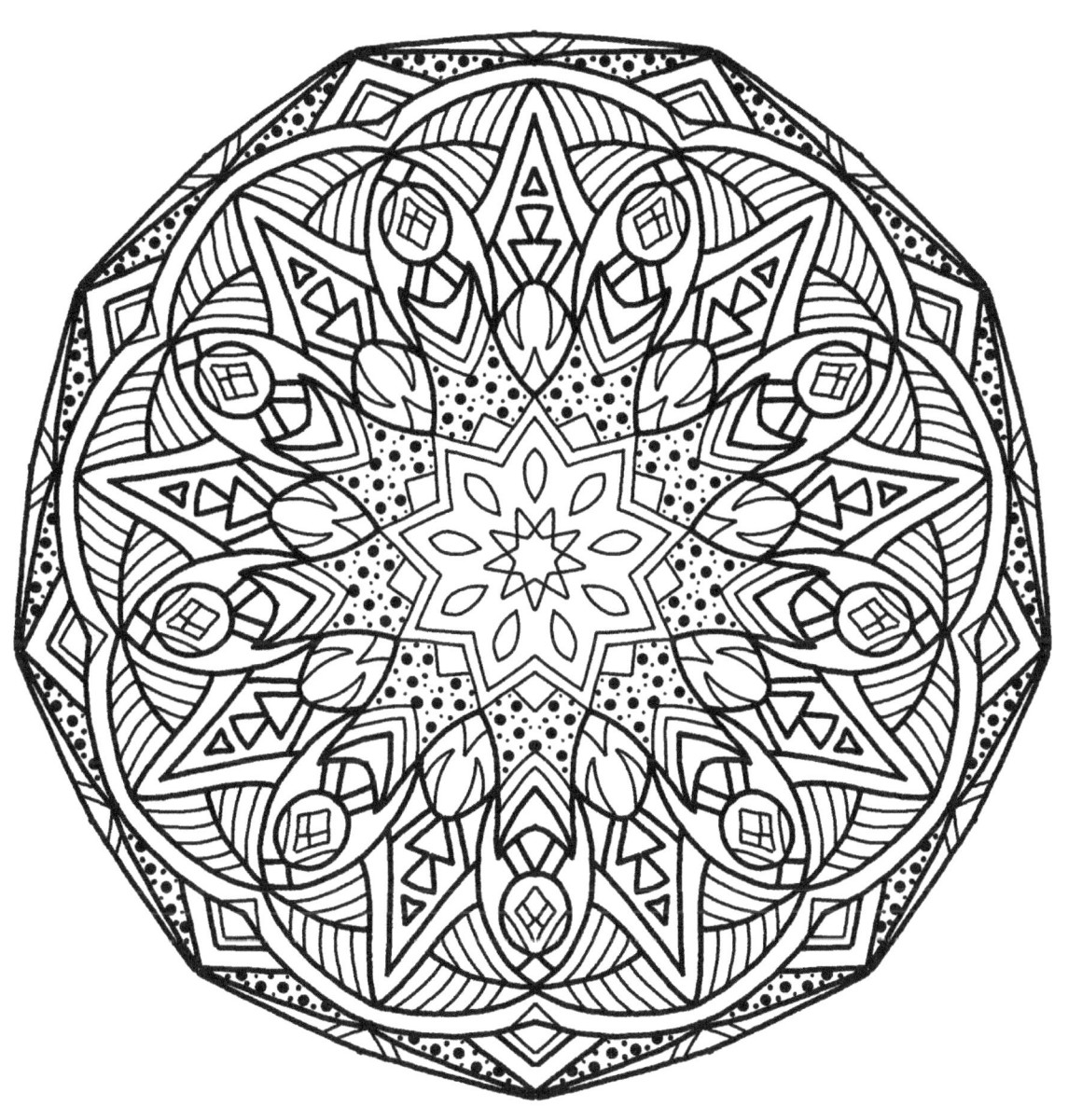

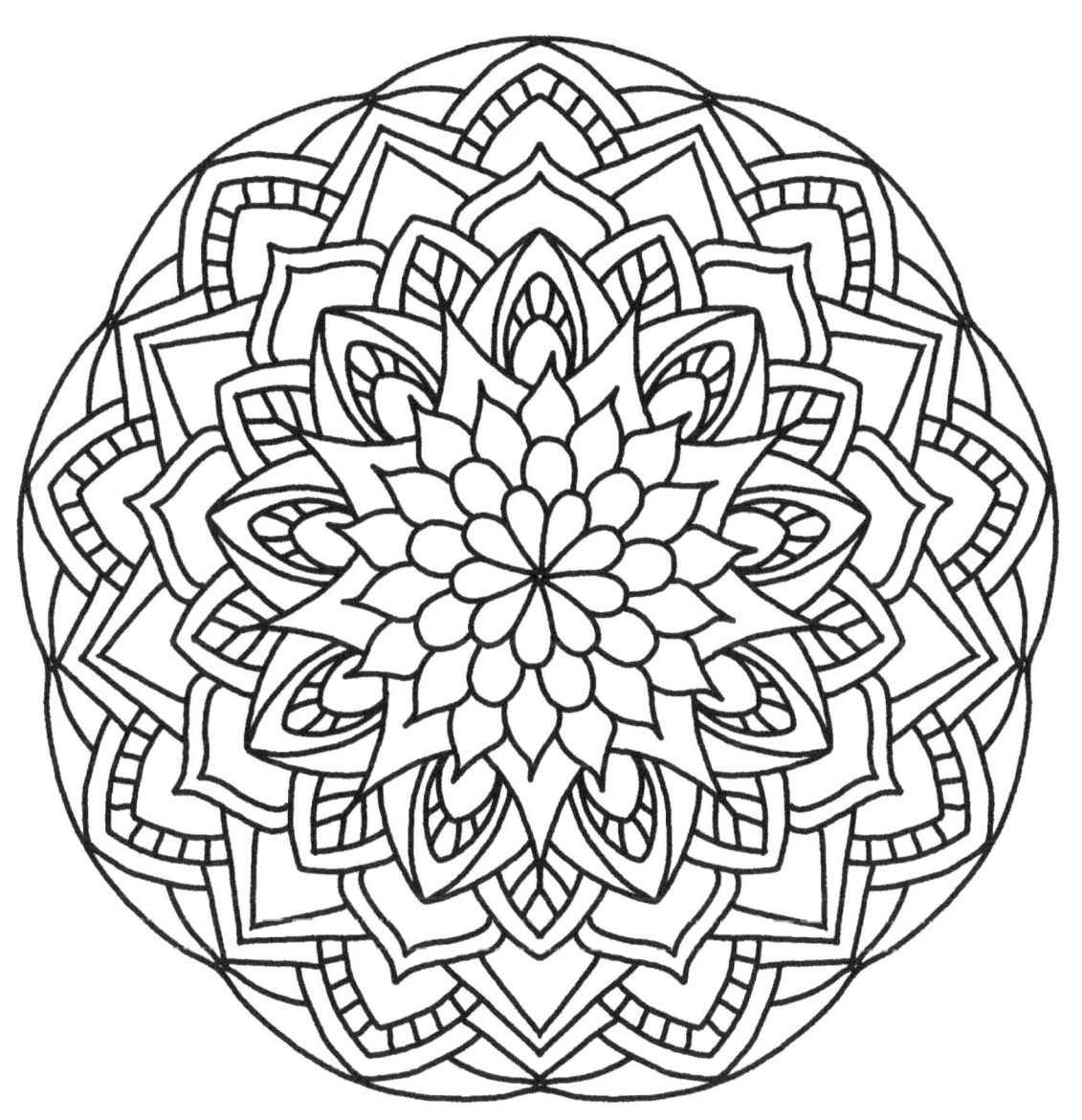

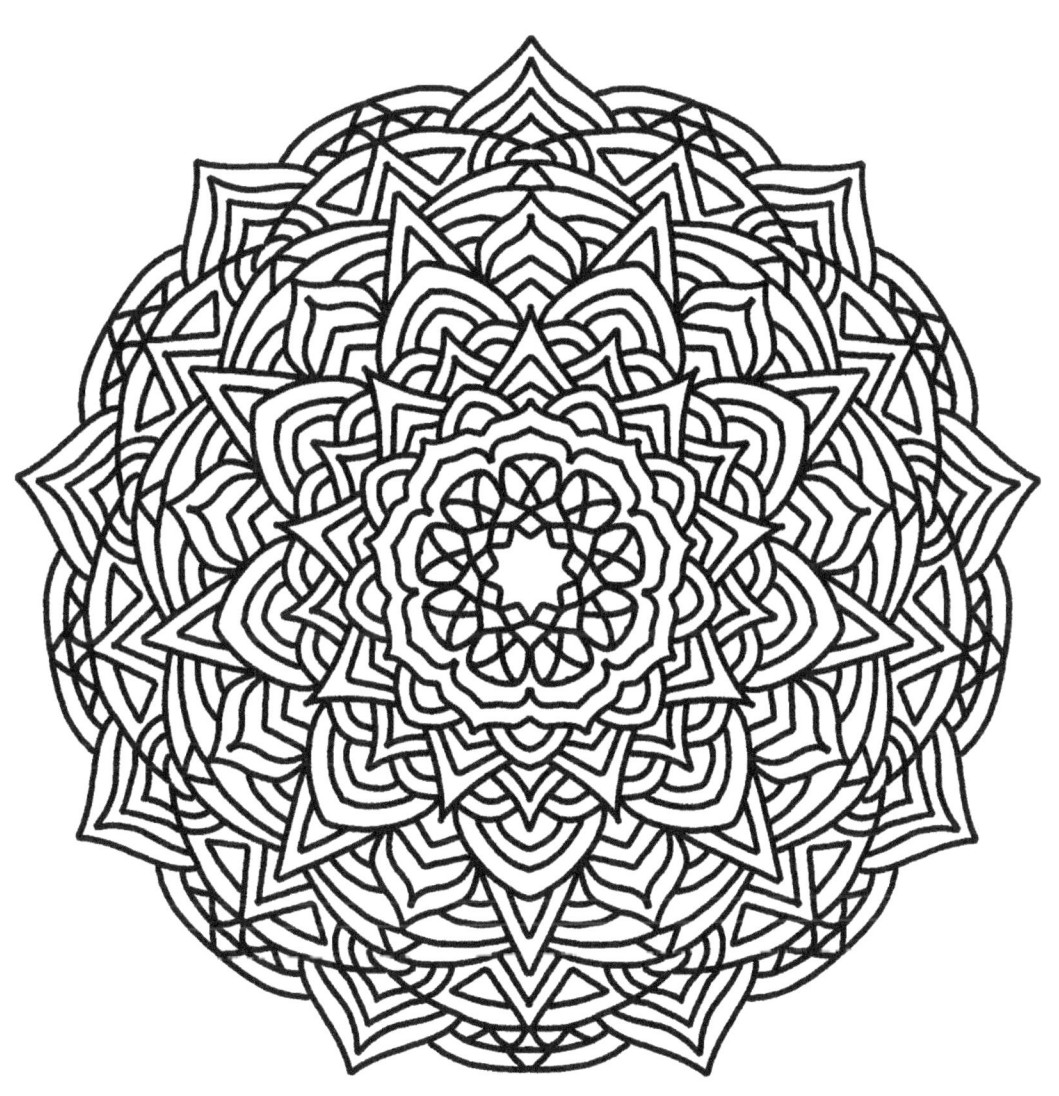

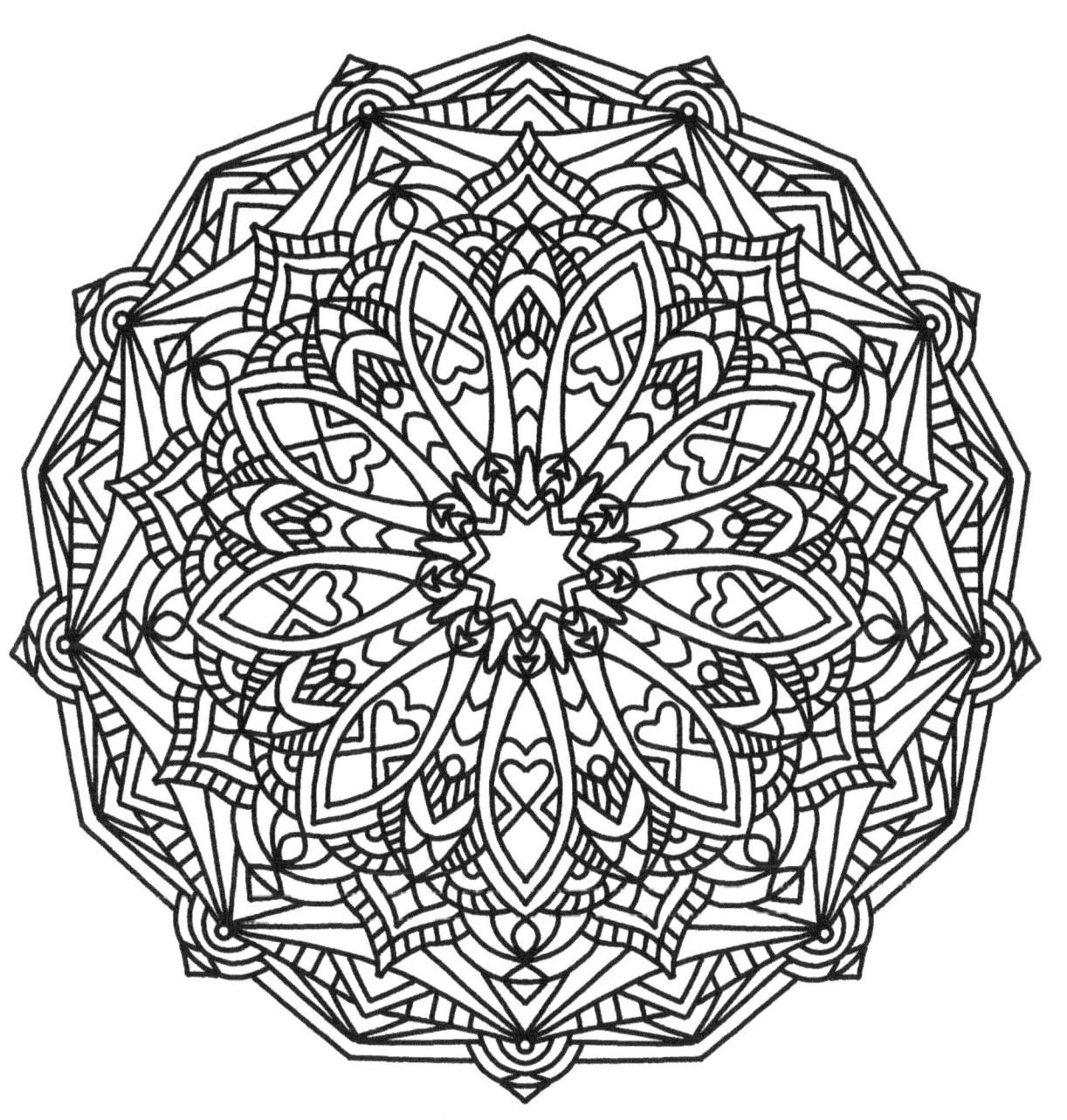

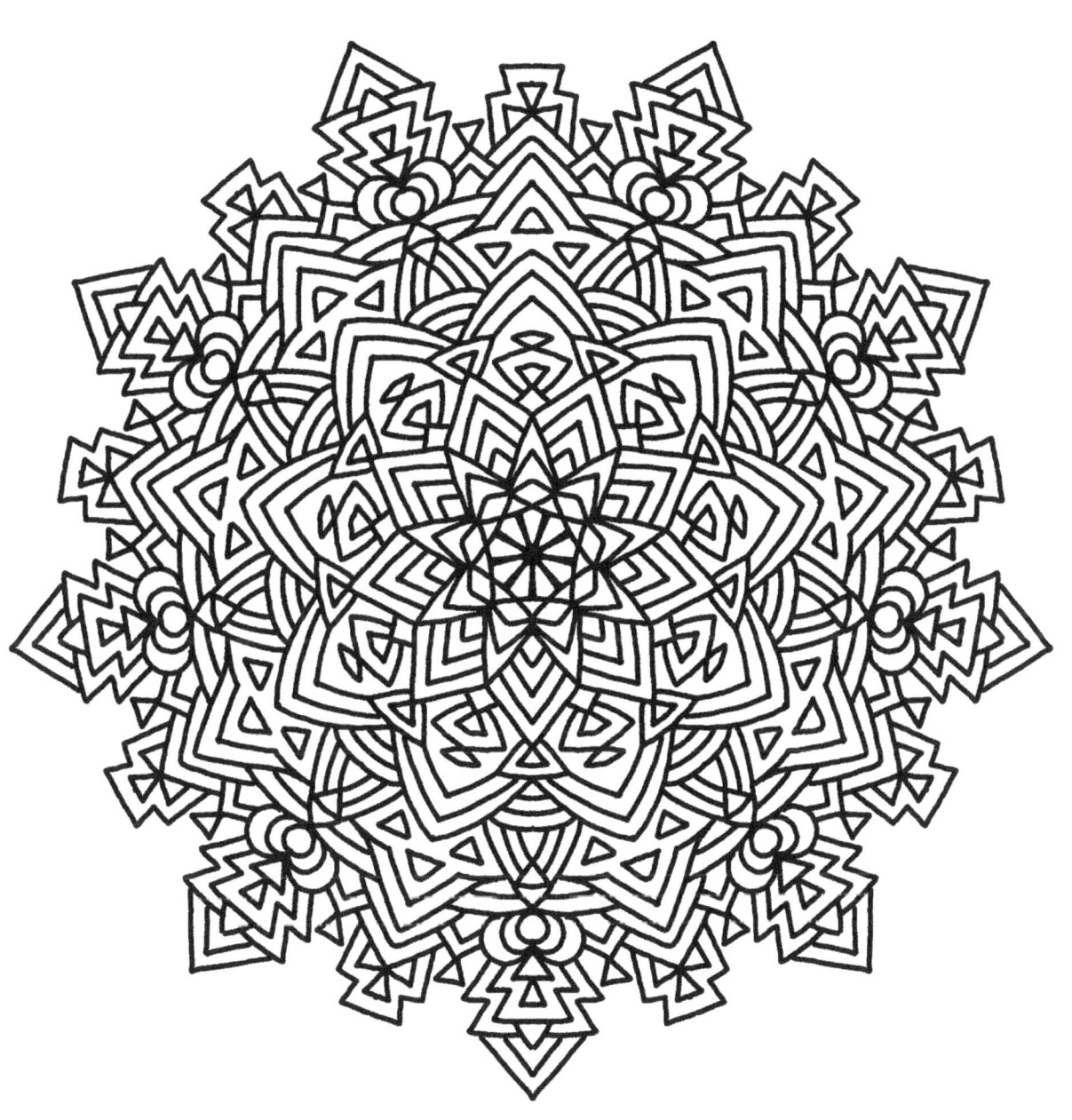

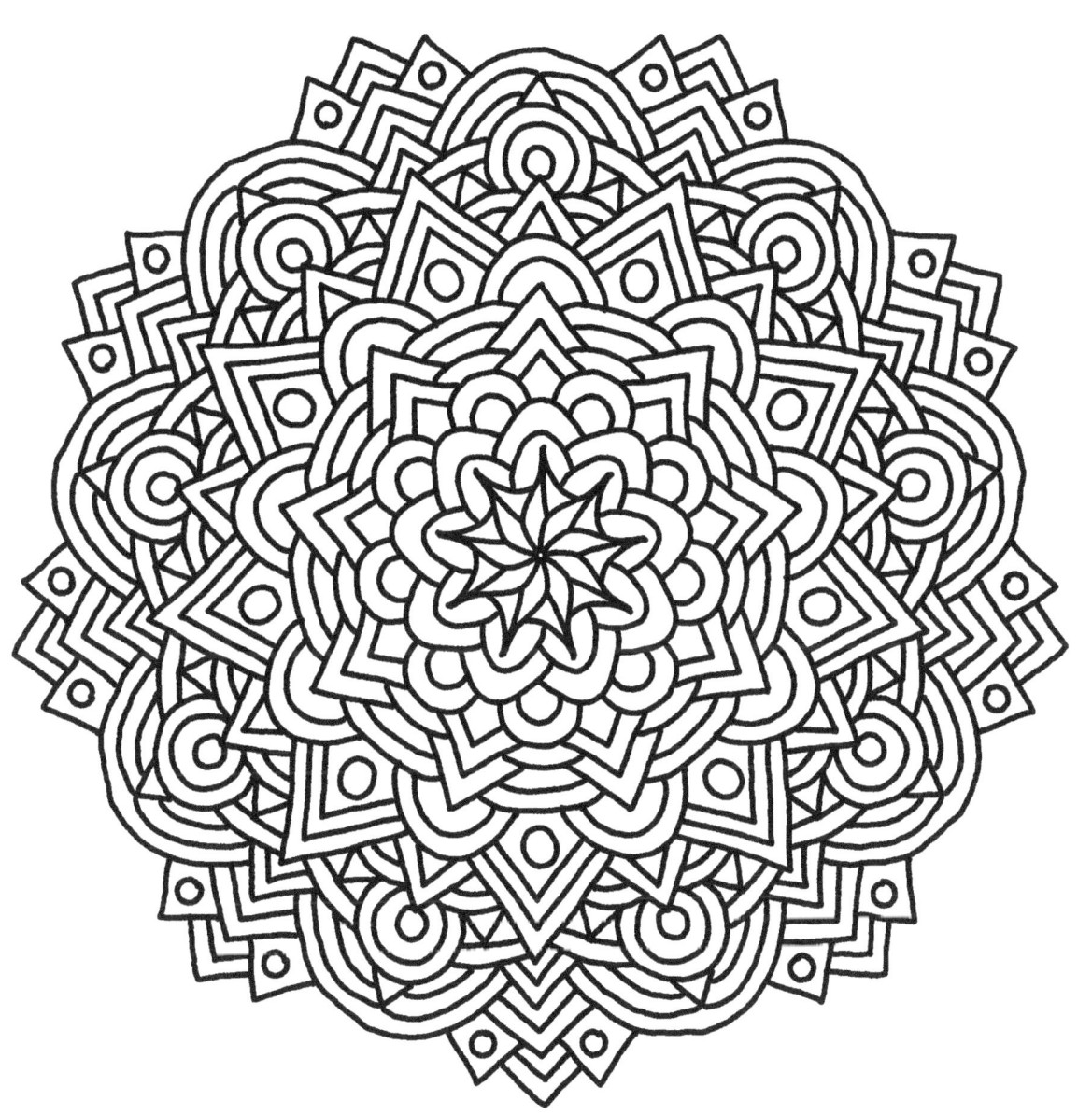

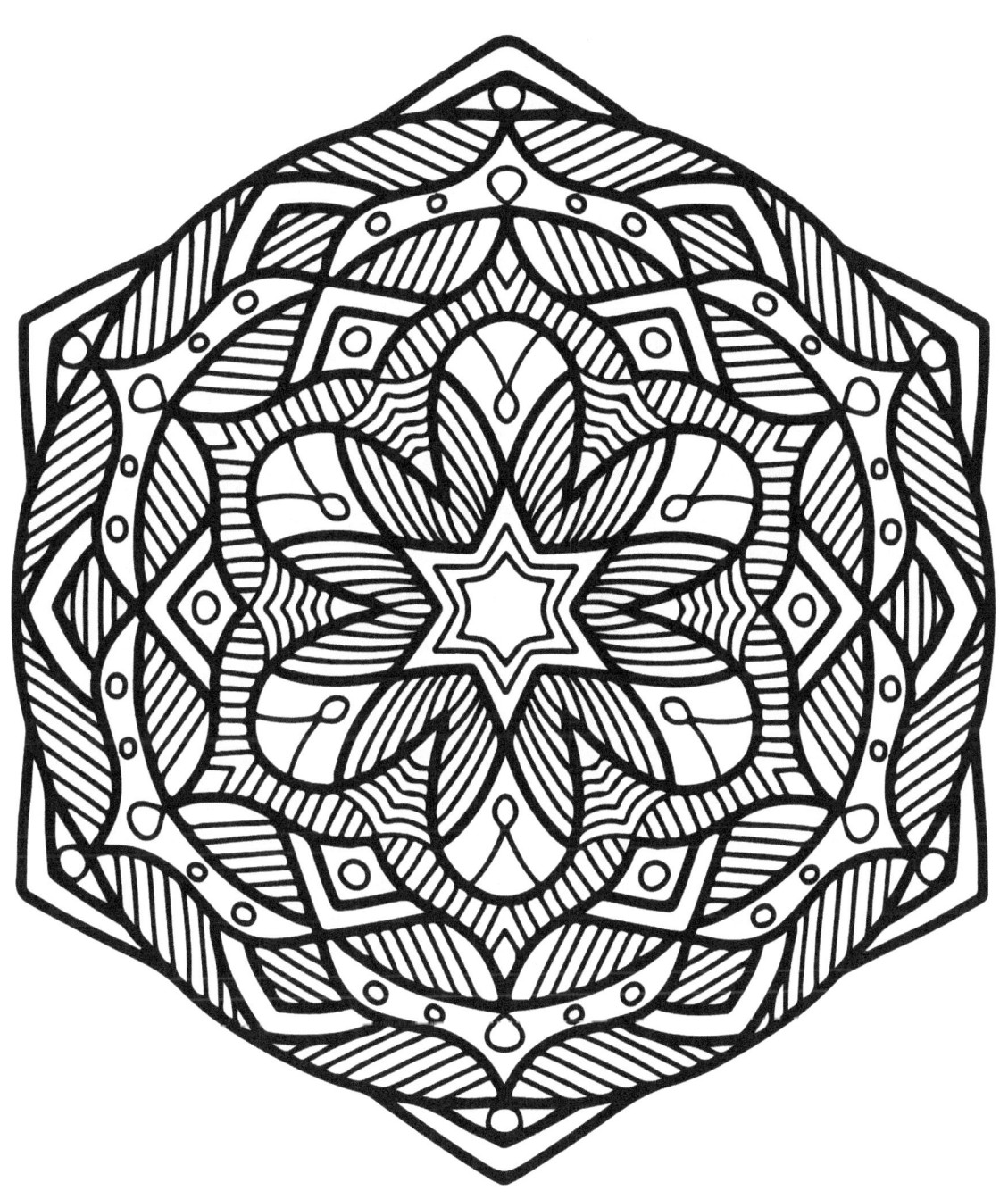

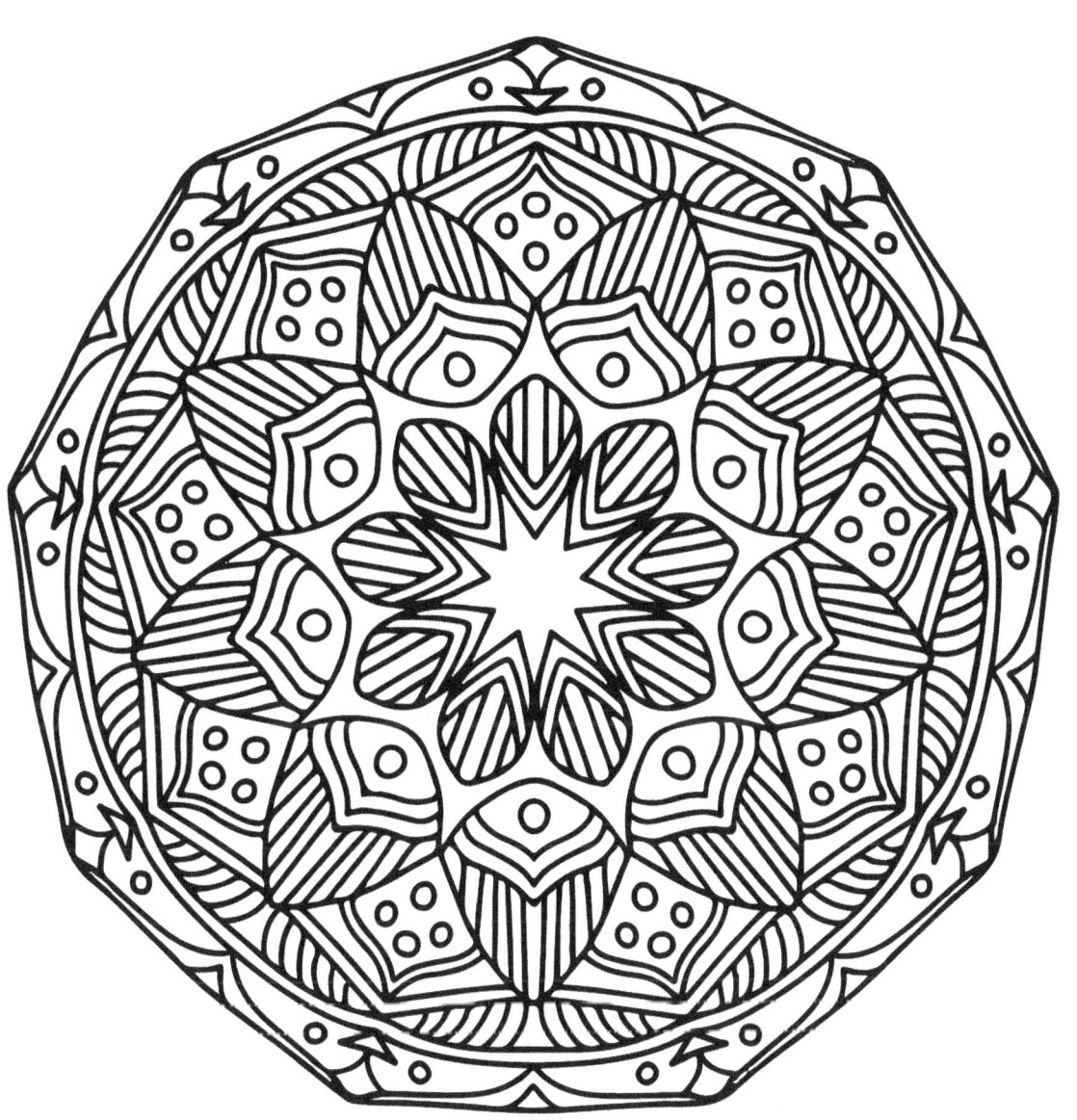

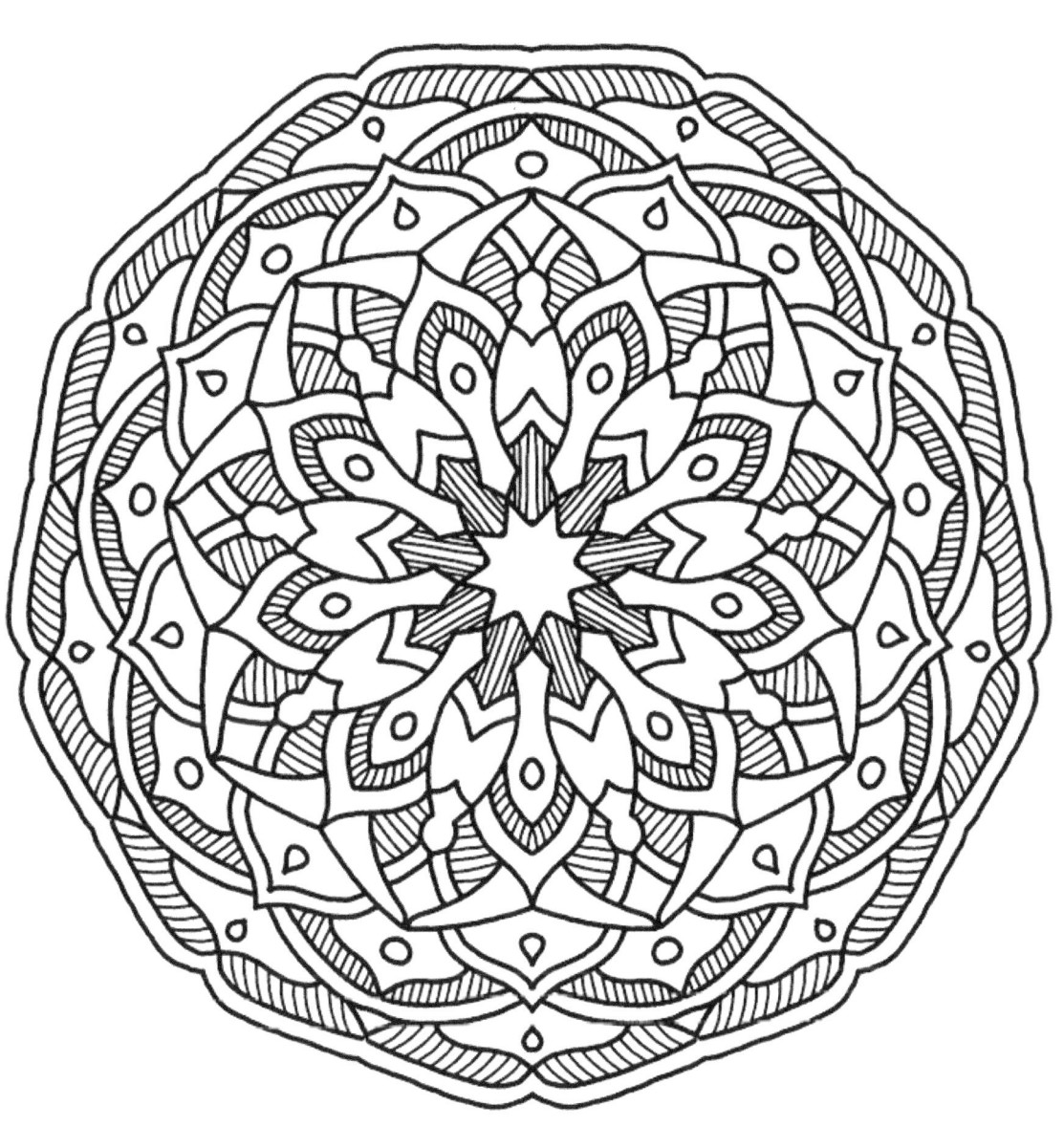

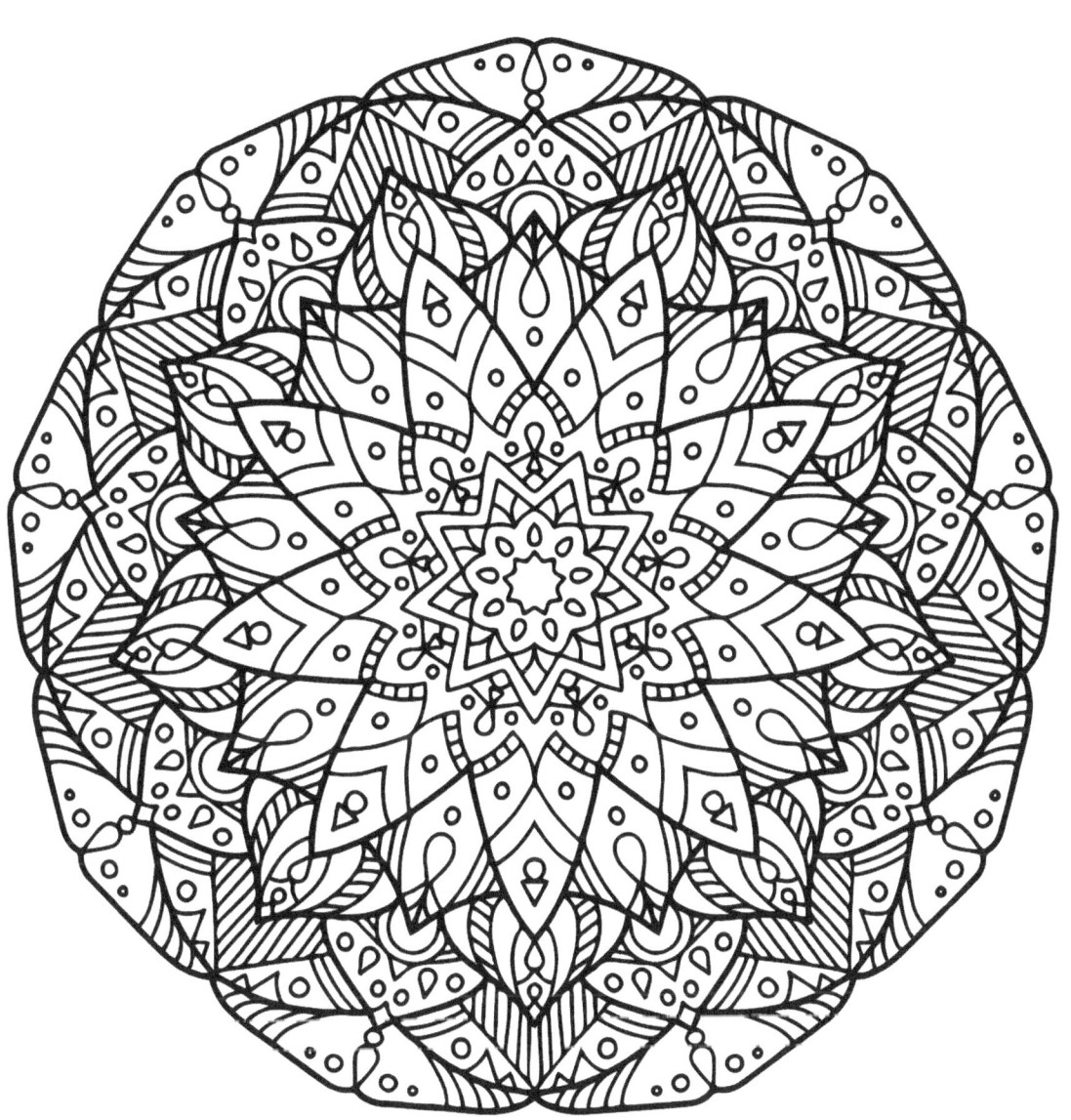

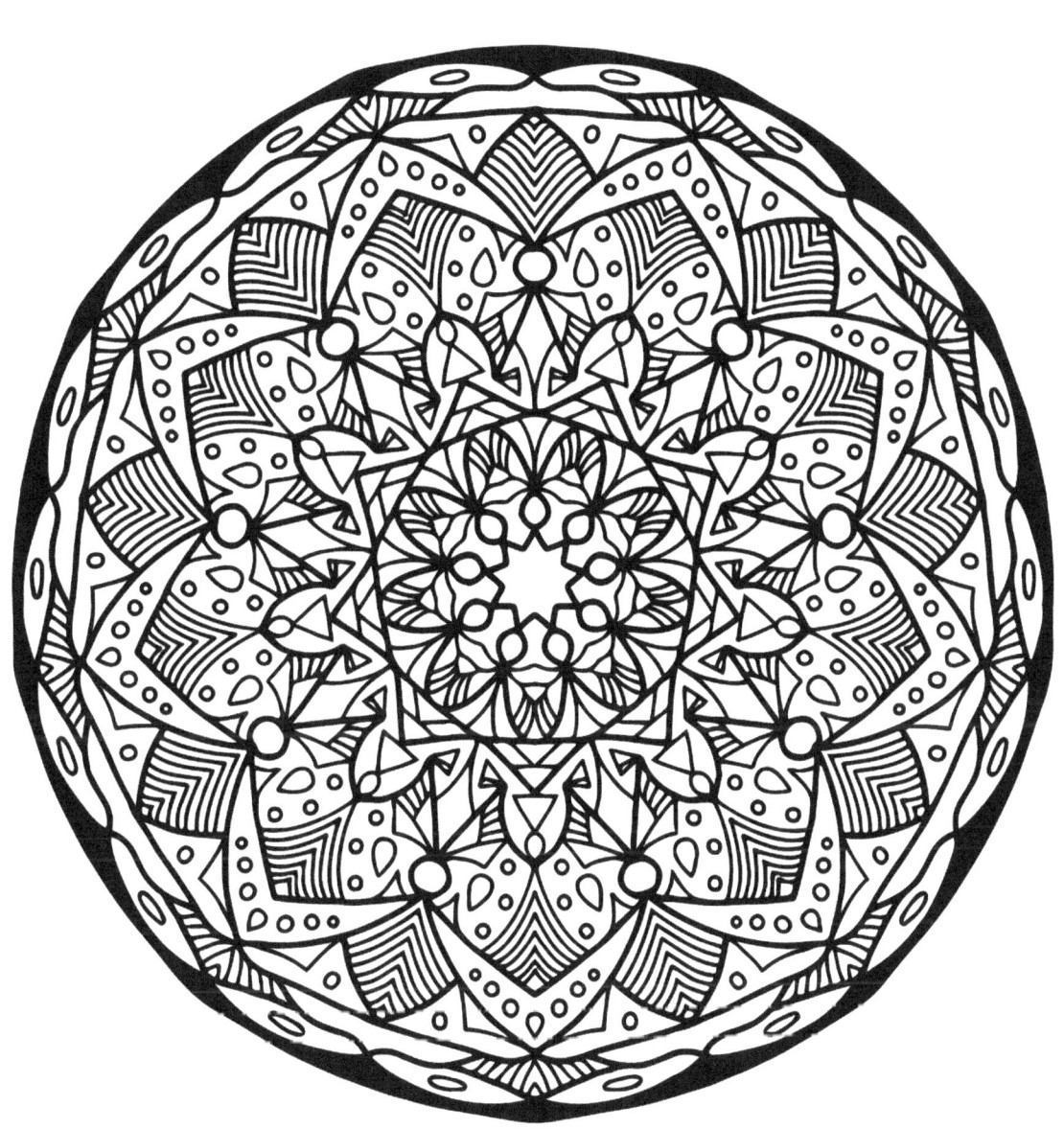

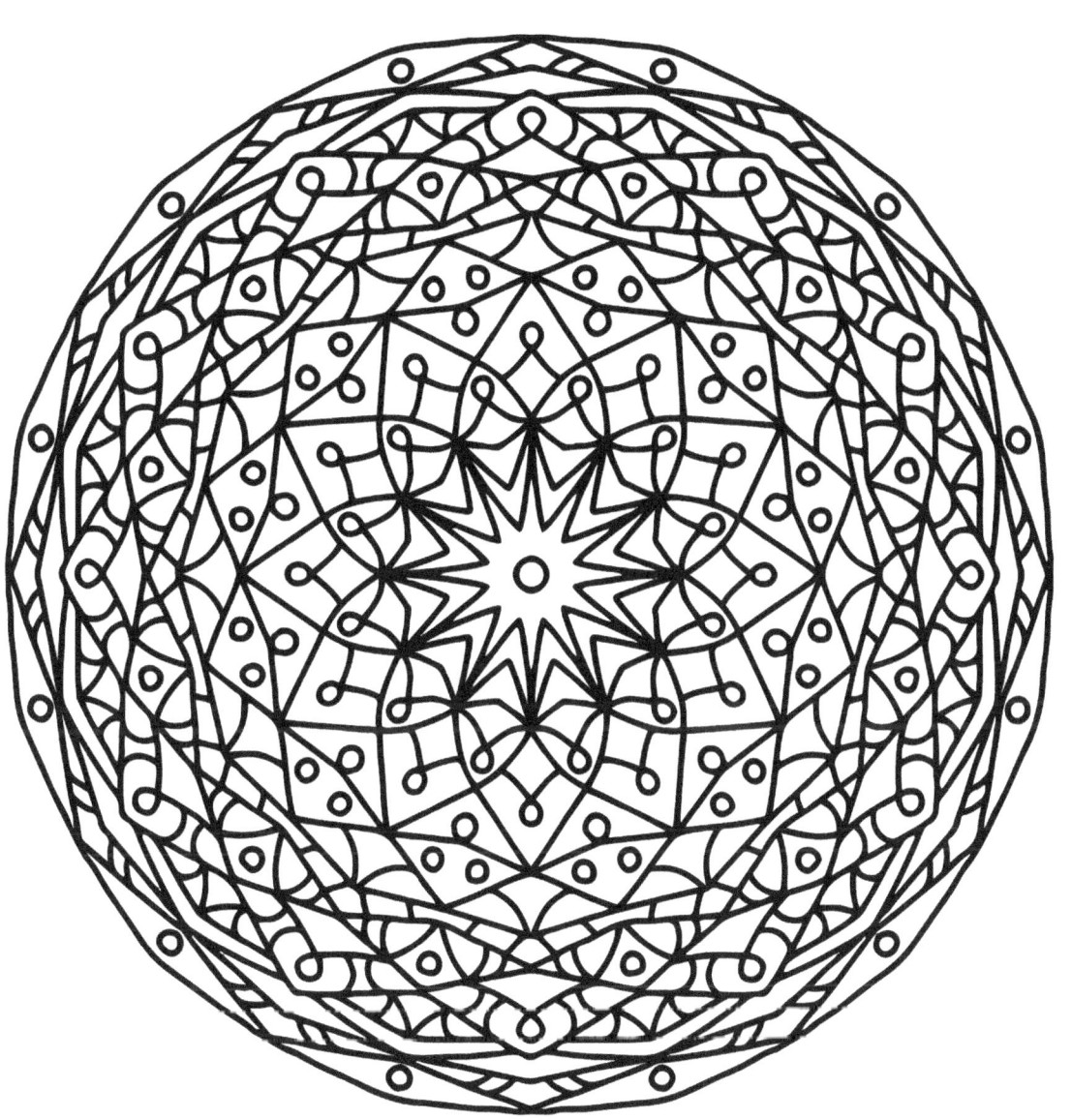

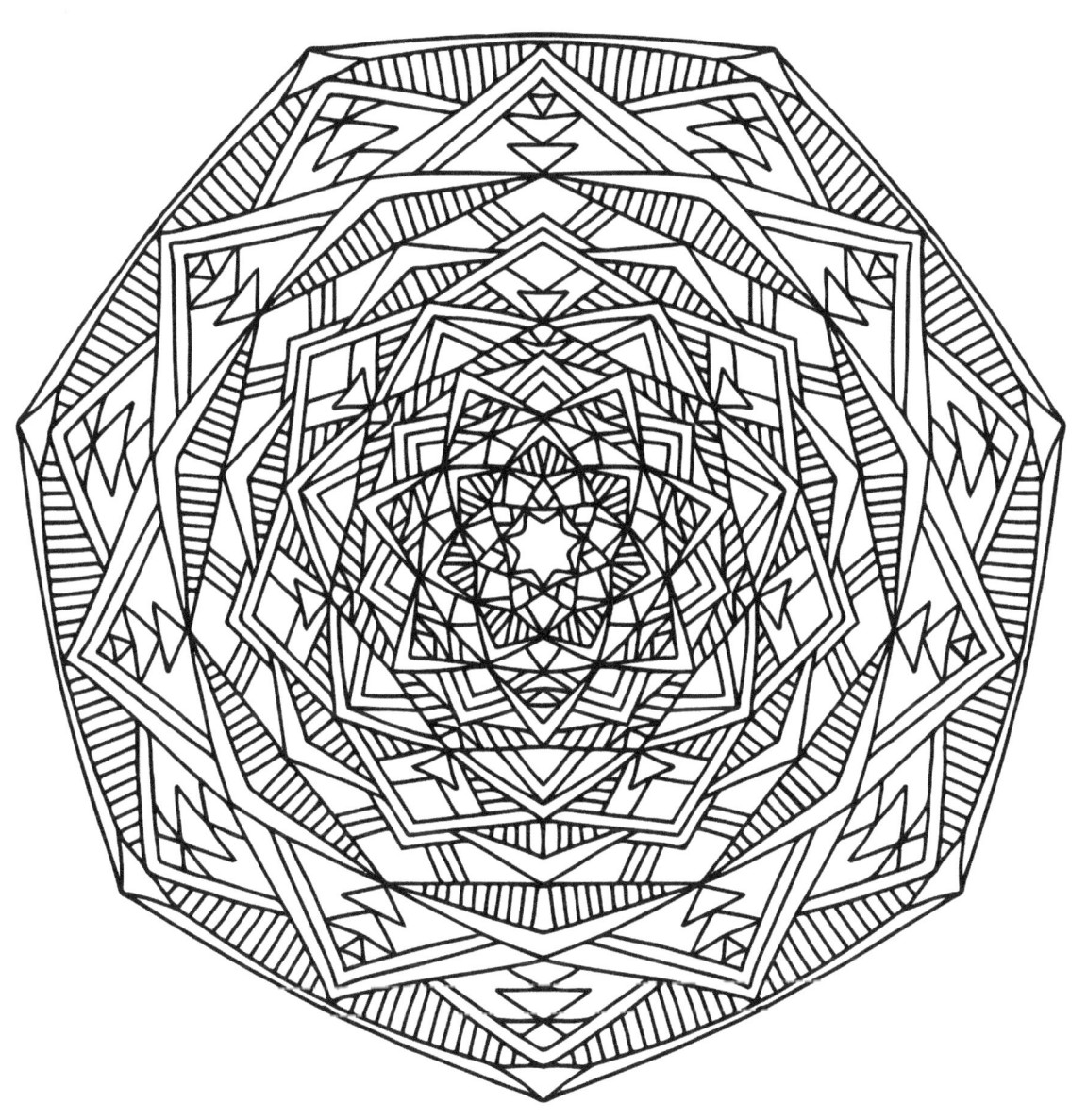

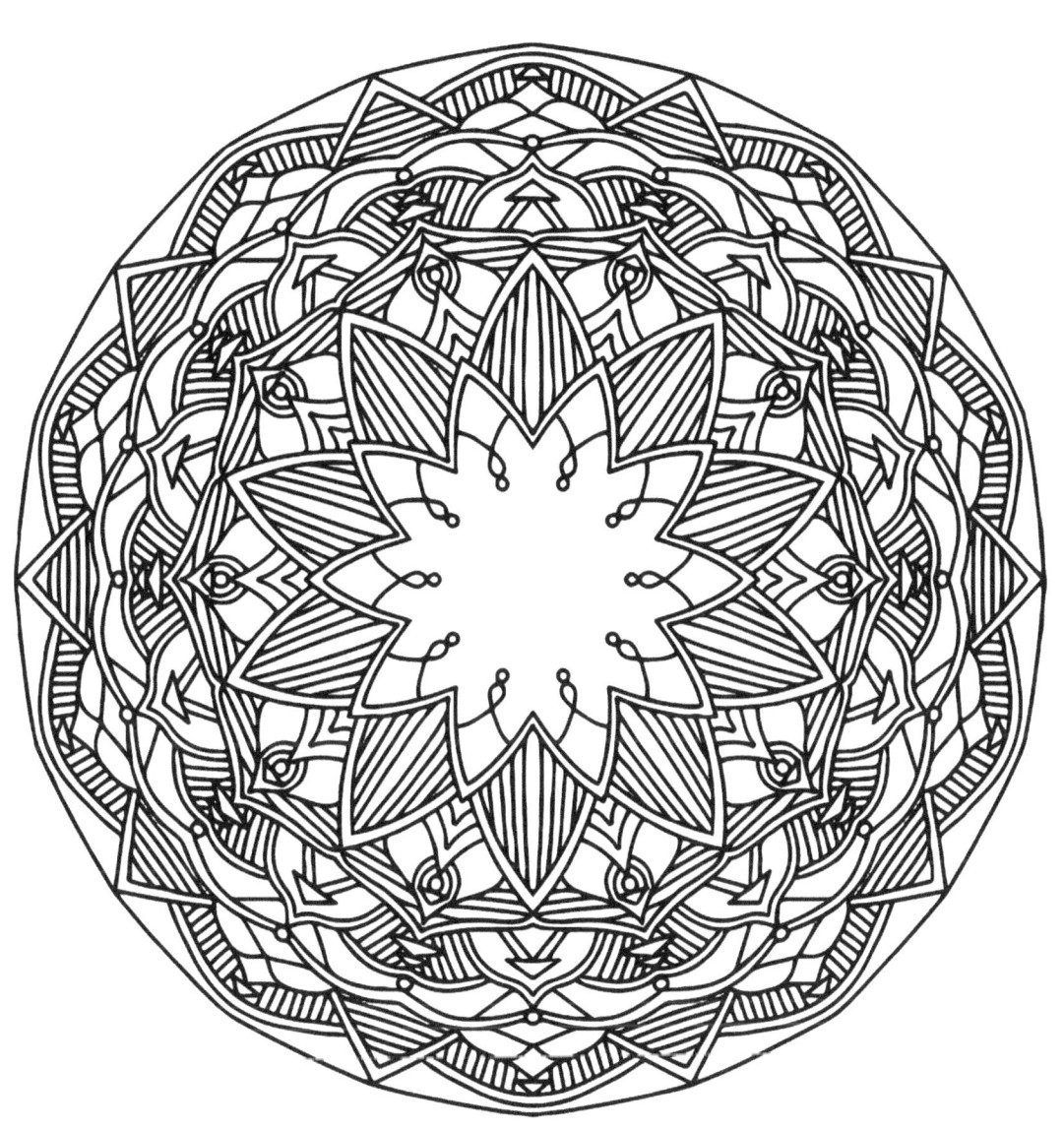

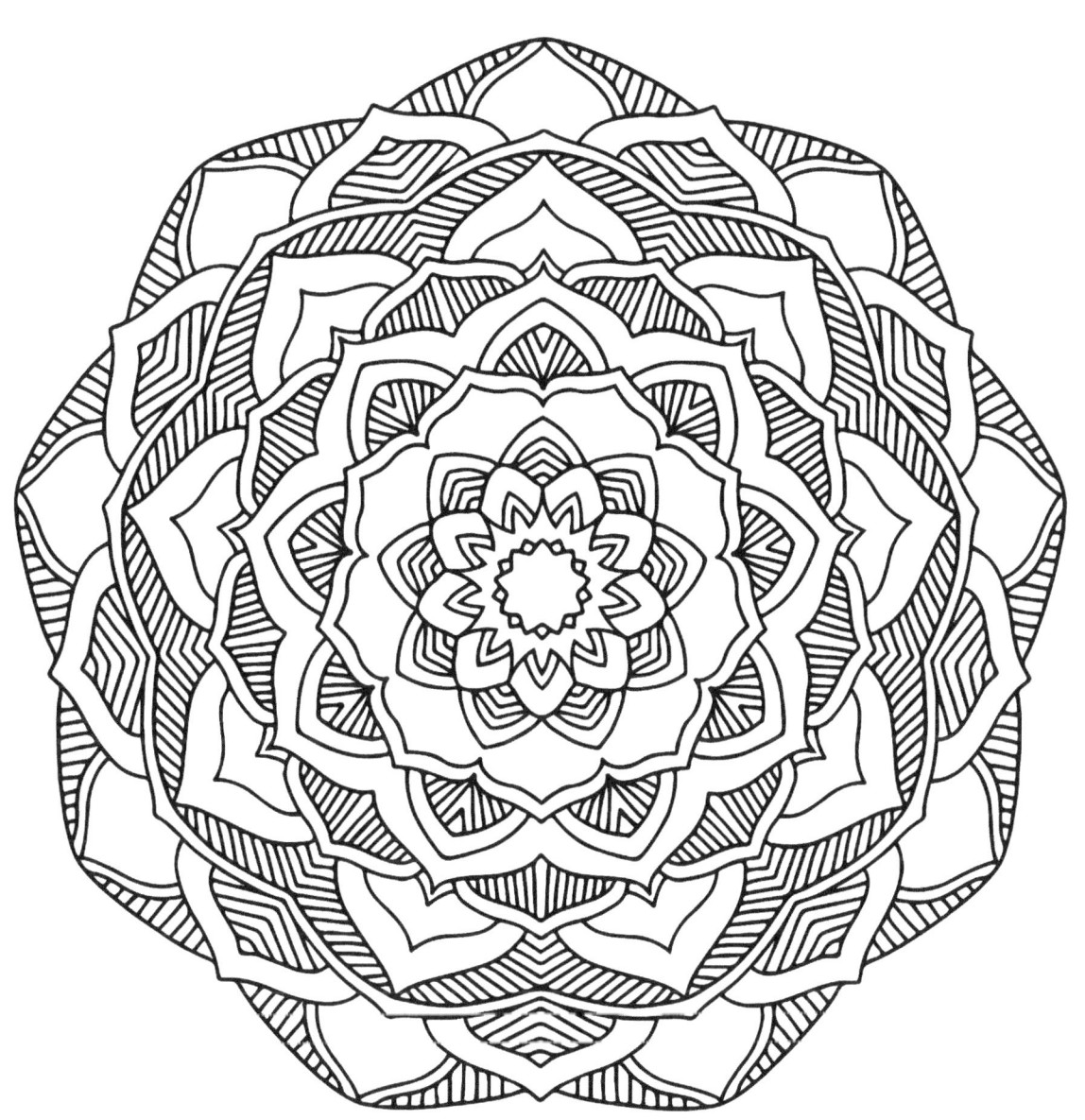

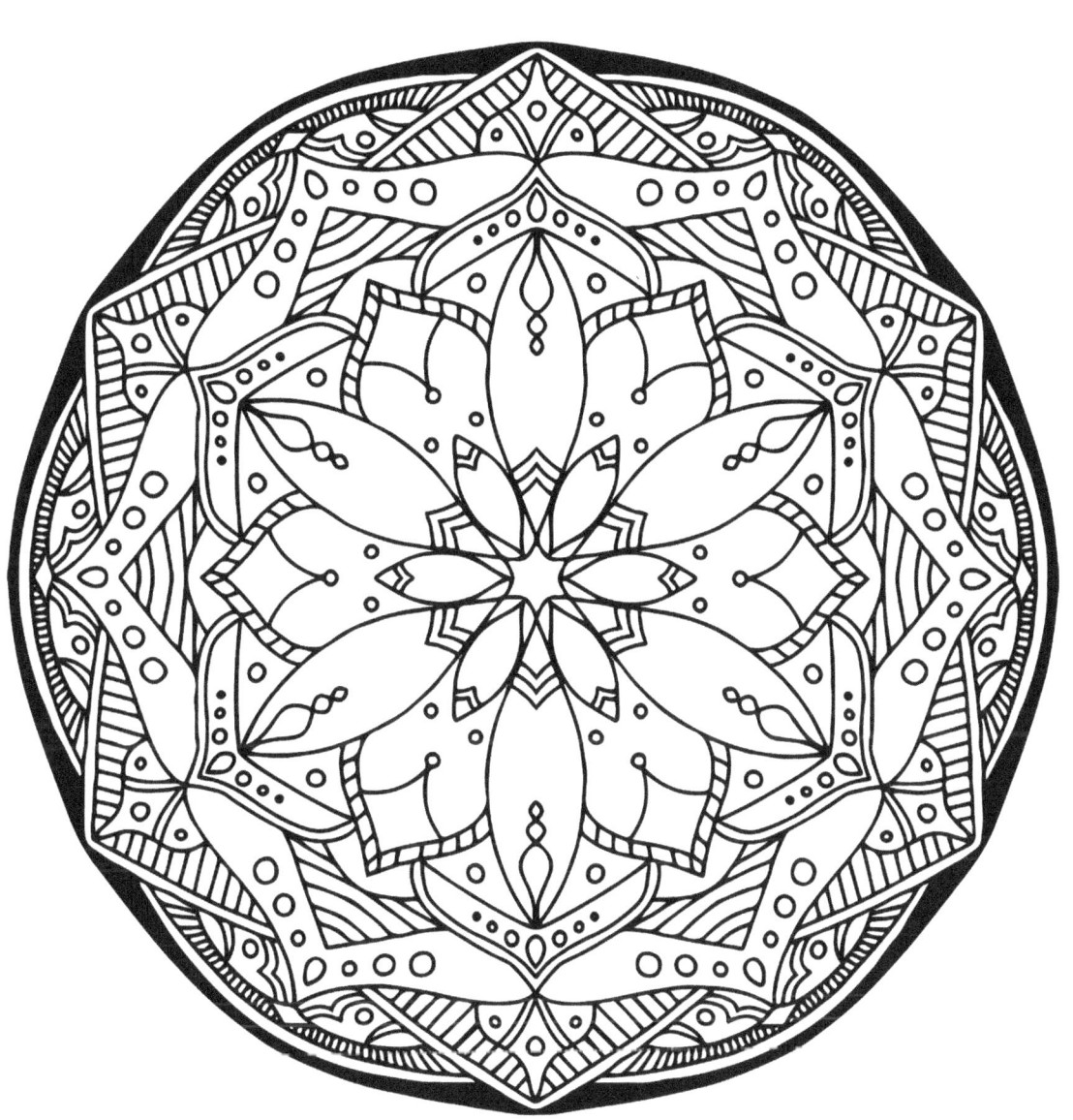

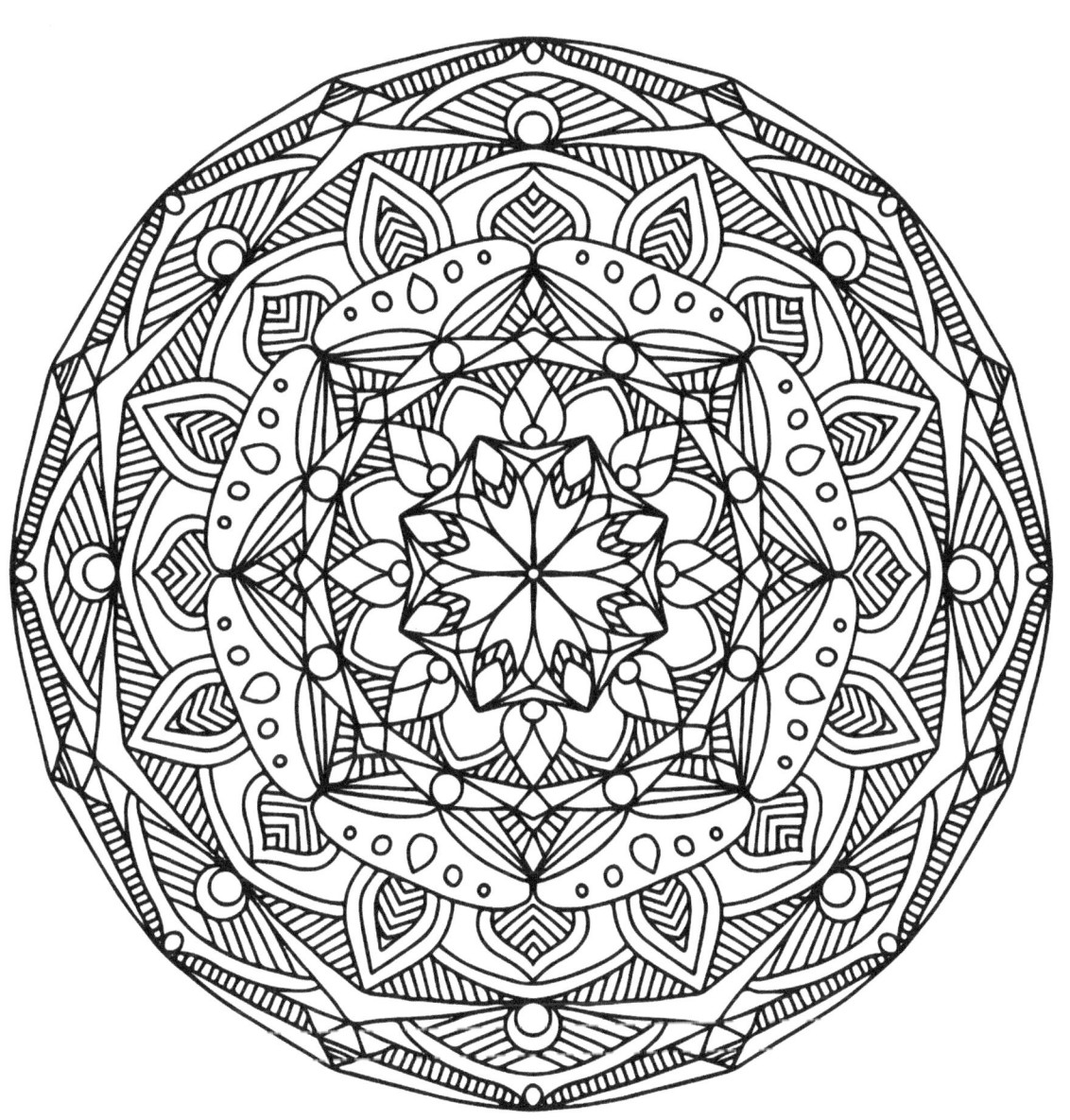

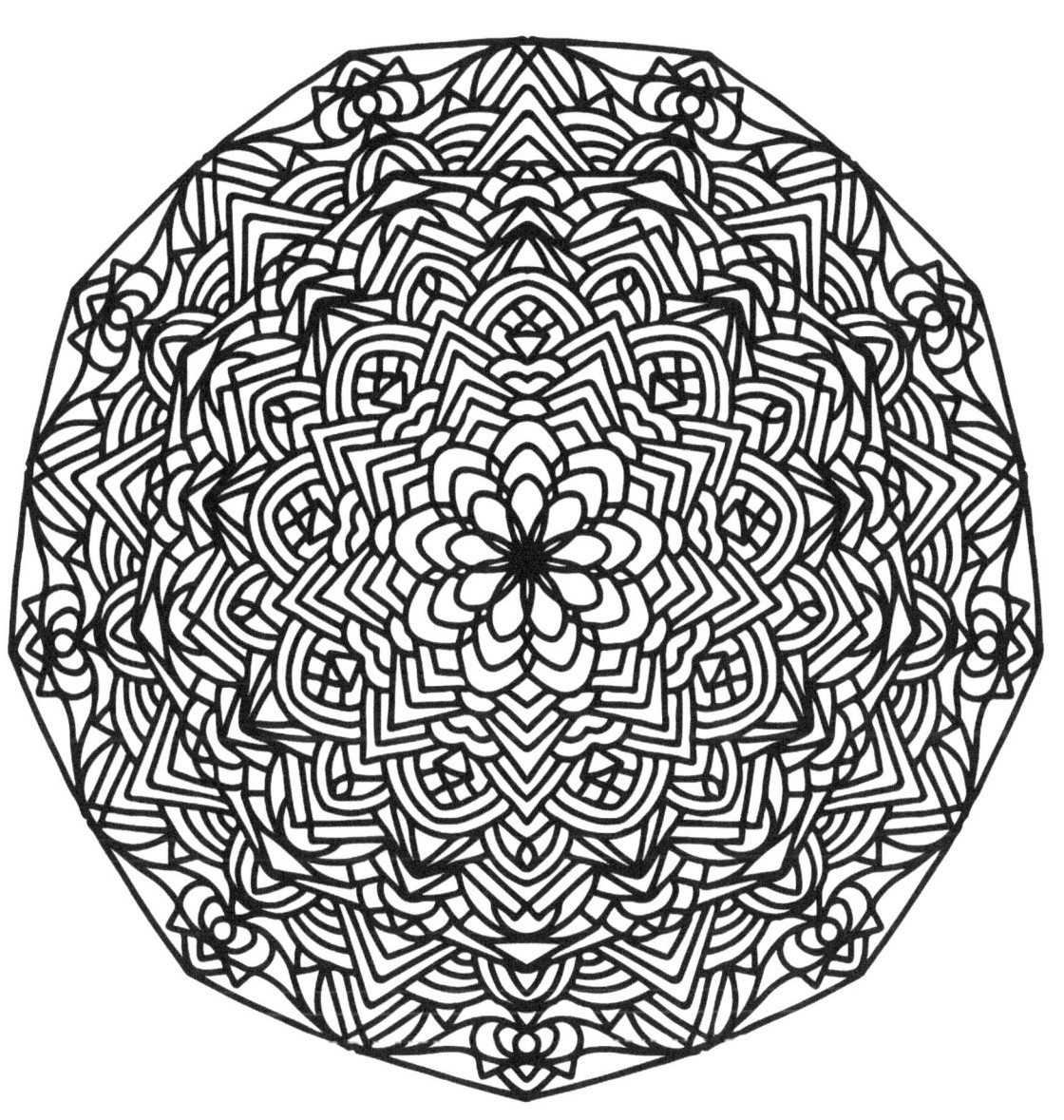

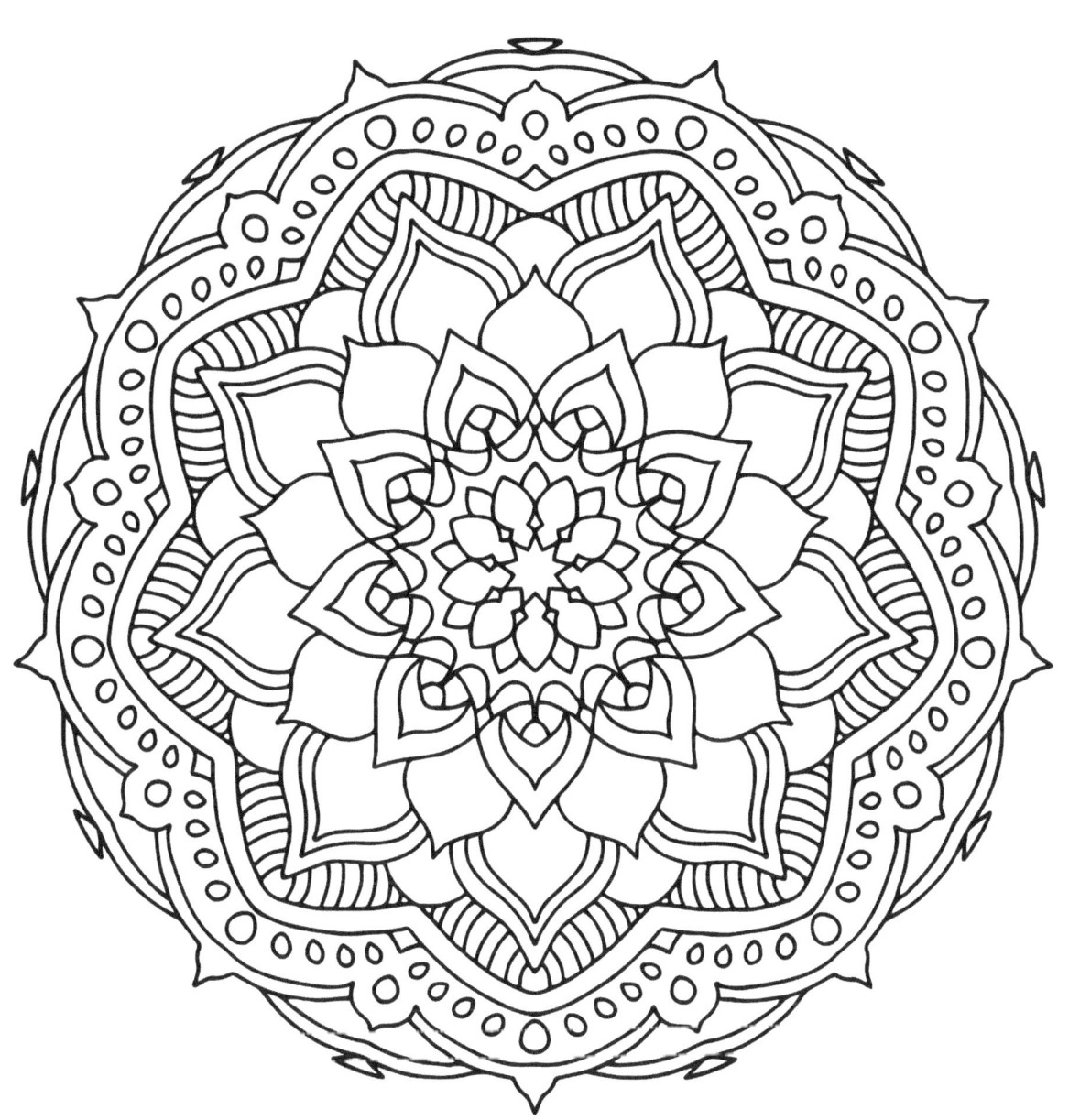

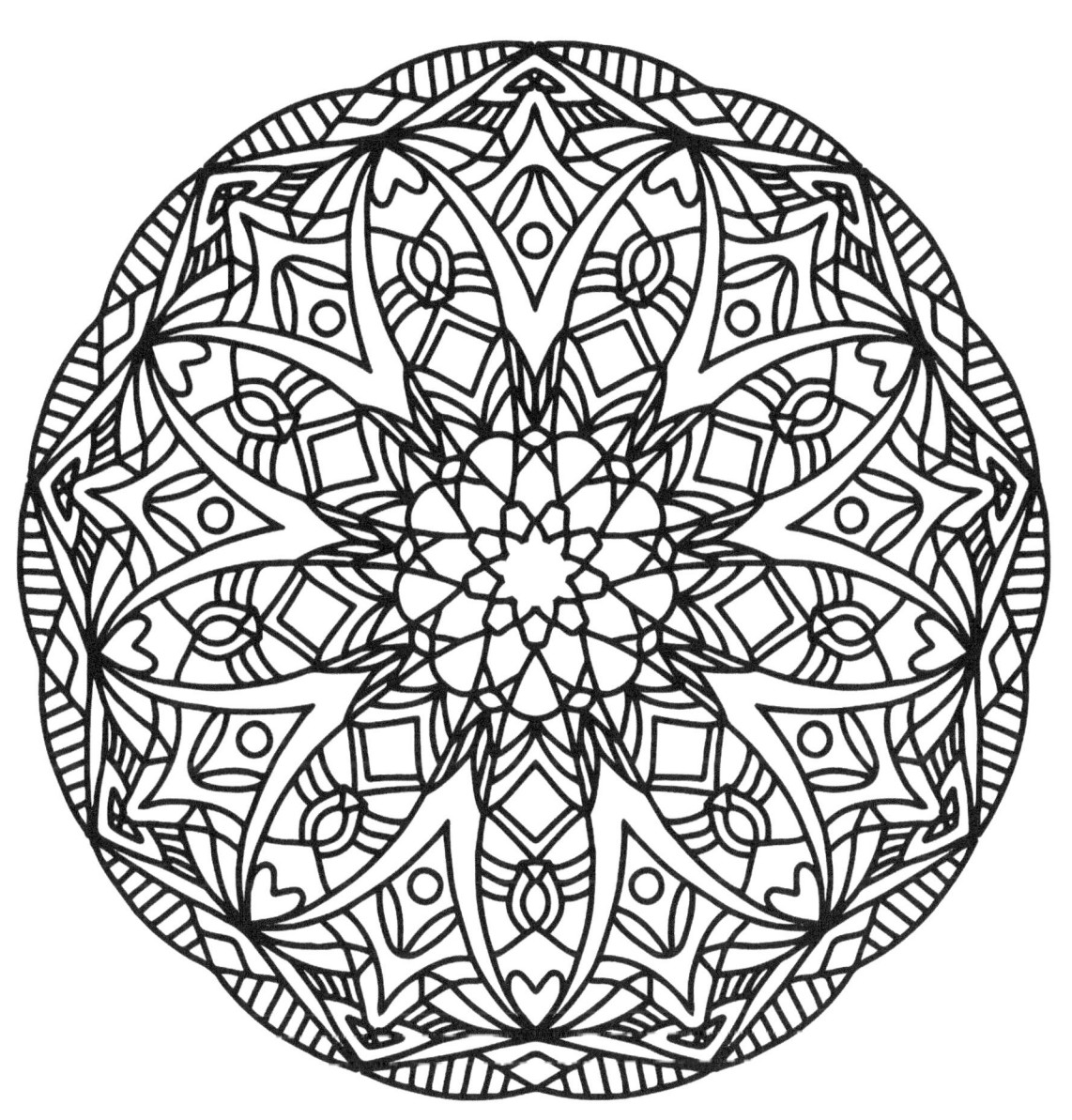

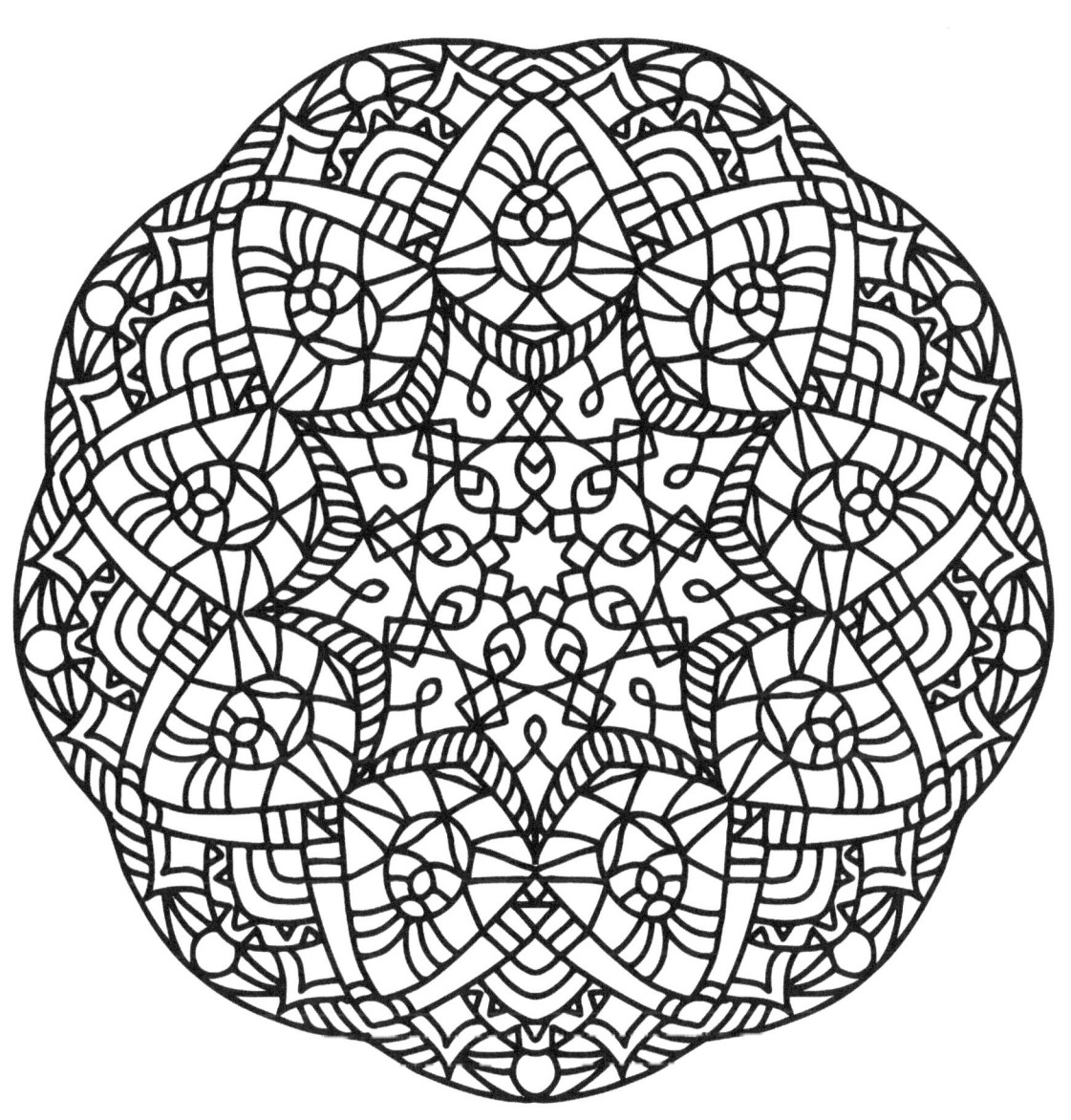

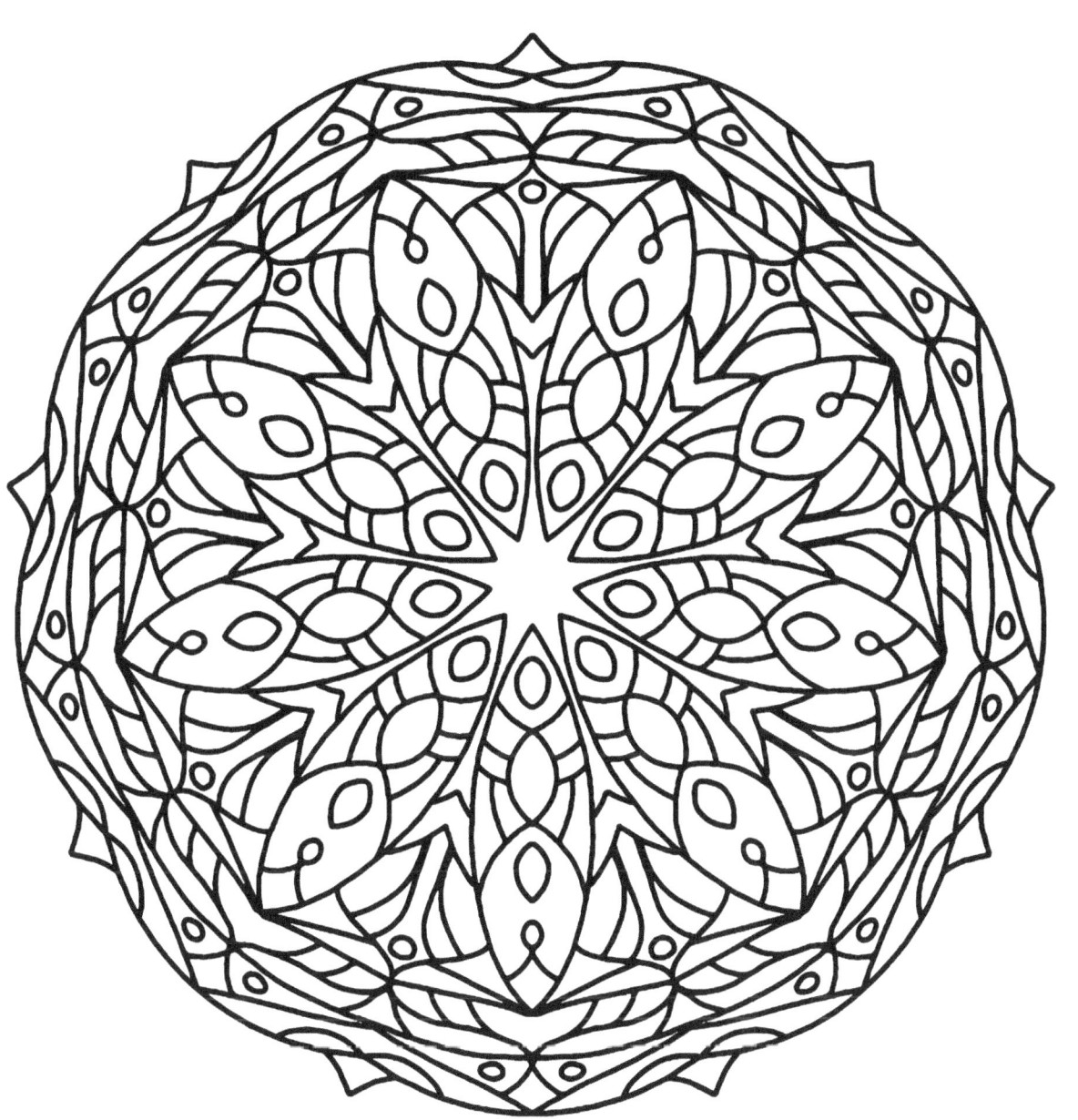

www.ingramcontent.com/pod-product-compliance
Lightning Source LLC
Chambersburg PA
CBHW080712190526
45169CB00006B/2349